FRAGILE LAND

D1352298

This play is dedicated to my brother – Teertha Gupta

Tanika Gupta
FRAGILE LAND

OBERON BOOKS
LONDON

First published in 2003 by Oberon Books Ltd.
(incorporating Absolute Classics)
521 Caledonian Road, London N7 9RH
Tel: 020 7607 3637 / Fax: 020 7607 3629
e-mail: oberon.books@btinternet.com
www.oberonbooks.com

A catalogue record for this book is available from the British
Library.

ISBN: 1 84002 367 8

Cover design: Andrzej Klimowski

Printed in Great Britain by Antony Rowe Ltd, Chippenham.

Characters

QUASIM

14-year-old Asian youth. Small, wiry. Omar's sidekick.

OMAR

16-year-old Asian youth. Lives above the sweet shop.
Loudmouth, streetwise.

TASLEEMA

Known as 'Tas'. 17-year-old Asian young woman.

LUX

Short for Laksmi. 17-year-old Asian young woman.
Beautiful, sexy. Tasleema's best friend.

HASSAN

19-year-old Afghanistani youth. Smooth-talking.
Tasleema's boyfriend.

FIDEL

17-year-old white youth. Lux's friend.

The play is set in 2003, mainly outside an
Indian sweet shop 'Ladoo' in Central London.
Other areas are a bus stop, Fidel's bedroom
and the characters' dreamscapes.

Fragile Land was first performed at Hampstead Theatre, London on 25 March 2003, with the following cast:

QUASIM, Tariq Jordan Shami

OMAR, Christopher Simpson

TASLEEMA, Medhavi Patel

LUX, Paven Virk

HASSAN, Elyes Gabel

FIDEL, Tom Burke

Director, Paul Miller

Designer, Simon Daw

Lightning Designer, Robert Bryan

Sound Designer, Scott George

ACT ONE

Scene 1

Set: the front of an Indian sweet shop called 'Ladoo'. We see a delicious array of Indian sweets on display in the window. There is a small flat above the shop with a window. Apart from the sweet shop front window, the appearance of the building is shabby and run down.

QUASIM enters. He is a fourteen-year-old youth, dressed shabbily in school uniform. He looks up at the window above the sweet shop.

QUASIM: Omar! Eight o'clock. Get your arse down here.
Omar!
Omar!!

There is no answer, so QUASIM picks up some empty beer cans and chucks them at the window.

OMAR's face appears in the window above the shop. He is undressed, hair tussled etc.

OMAR: What's up man?

QUASIM: You should be up! Look at you! You're not even fucking dressed.

OMAR: Kas man, d'you have to shout like that? We're not back in your dad's village – innit.

QUASIM: You told me to make sure you got up.

OMAR: Alright, alright, keep your hair on.

OMAR disappears back into the house.

QUASIM: (*Calls up.*) If you're late one more time, we'll be in deep shit…

OMAR: (*Calls back.*) Quit shouting, I'm up.

TASLEEMA and LUX enter, both dressed casually for school (they are in the sixth form). LUX is beautifully made up and looks immaculate – almost model-like. QUASIM watches TASLEEMA with interest whilst he kicks a football around. LUX gets out a mirror from her bag and applies some lip-gloss.

LUX: What's the crack?

TASLEEMA: Hanging loose. You?

LUX: Avoiding Assembly.

TASLEEMA: Same here. (*Sniffs the air.*) What's the stink?

LUX: D'you mind? It's fragrance – *parfum.* My aunt bought it me. Duty-free from Dubai.

TASLEEMA: Smells like cat's pee drained through a dirty balaclava.

LUX: No it doesn't. It's Yves Saint Laurent. Bitch.

TASLEEMA smiles.

Hey Tas. What does 'Ami Tomake bhalo bashi' mean?

TASLEEMA laughs.

What?

TASLEEMA: Who said that to you?

LUX: What's it mean?

TASLEEMA: 'I love you.'

LUX smiles, pleased but embarrassed for a moment.

TASLEEMA looks at LUX suspiciously.

Who?

LUX: No one.

QUASIM smiles hopefully at TASLEEMA. She ignores him.

You thought any more about what you wanna do?

TASLEEMA: Nah. What with no cash and Abba breathing down my neck every second of the day, don't see how I can have any fun.

LUX: Only two weeks to go – then you're free. Do what you wanna do, make your own plans. Your dad can't boss you around anymore.

TASLEEMA: Try telling him that.
I wanna finish my A levels. I've gotta get my grades…
I wanna be someone.

LUX: An educated housewife.

TASLEEMA: Fuck off.

LUX: You might as well get used to the idea, 'cos that's what your Abba's got lined up for you. Nice Bengali boy, good teeth, steady income and a healthy body.

TASLEEMA: Stop it.

LUX: You supply the passport and he'll supply the sperm.

TASLEEMA: Lux!

LUX: Face facts.

TASLEEMA: Shut up bitch!

LUX looks at TASLEEMA surprised. QUASIM gets out a football magazine and sits on the step reading it. Really, he's eavesdropping.

LUX: You're so easy to wind up.

TASLEEMA looks upset.

You heard from – Nasreen?

TASLEEMA: Yesterday.

LUX: And?

TASLEEMA: I hate her.

9

LUX: How come? Thought the sun shone out of her árse.

TASLEEMA: She's landed me in it. Now that she's fucked off, Abba's come down on me heavy. It's like he's on a mission or something. Got to prove that he can produce one obedient daughter.

LUX: He's just worried that's all.

TASLEEMA: Never talks about her, never even mentions her name. It's like the day she ran away, she stopped existing.

LUX: She still with the white boy?

TASLEEMA: Yeah.

LUX: Maybe it's true love.

LUX and TASLEEMA exchange a look which shows that neither believe it is.

TASLEEMA: Keep talking about sending me back.

LUX: It's all chat.

TASLEEMA: I think he's serious.

LUX: Nah…

TASLEEMA: One day I'll find myself on a one way trip to Bangladesh – trussed up in the back of the car on the way to Heathrow.

LUX: Even he wouldn't do that.

TASLEEMA: What makes you so sure?

LUX: 'Cos you're dead clever Tas. You could be anything you wanna be – a doctor, a nurse – I dunno – even a professor. All those fucking GCSEs you got…your dad wouldn't give up all that glory would he?

TASLEEMA: You're forgetting one thing.

LUX: What?

TASLEEMA: It doesn't count if you're a girl.

LUX: That's bollocks.

TASLEEMA: The cleverer you are, the more difficult it is to find a husband. That's what my dad says.

LUX: Smart man – your dad.

TASLEEMA: I'm serious Lux. That's what he thinks.

LUX: What he says is completely different to what he'd do.

TASLEEMA: He tried to force my sister.

LUX: Then he won't make the same mistake again and in two weeks everything'll be different.

QUASIM: What's happening in two weeks?

LUX: (*To QUASIM.*) Do you mind? We're having a private conversation here, dog breath.

QUASIM shuts up but continues to listen in. LUX pulls TASLEEMA aside.

I was talking to my cousin last night. She reckons we should skip school that day and head off down to Southall.

TASLEEMA: Southall?

LUX: They got clubs there at lunchtime innit? We could get a few mates together and have a rave. Put some party gear in our school bags, change there.

TASLEEMA looks interested. So does QUASIM.

Our fossils'll never find out. We'd be back in time for the end of school.

TASLEEMA: She been then? Your cousin?

OMAR comes out of the sweet shop. He is dressed (scruffily) for school. His jacket is half on and he's doing up his tie. The girls don't see him at first. OMAR stops and eyes LUX.

LUX: Yeah. There's this club called 'Stardust'. Meant to have amazing sounds and a massive dance floor.

TASLEEMA looks interested.

TASLEEMA: Sounds like it could be a laugh.

OMAR: What could be a laugh?

TASLEEMA and LUX ignore OMAR.

QUASIM: It's Tas's birthday in two weeks.

OMAR: Yeah – that's right. Eighteen innit? So? Where's the party?

LUX: Who said you were invited?

OMAR: You can't have a party without us.

LUX: Watch us.

OMAR: Come on, don't be like that. We're mates.

TASLEEMA: Since when?

OMAR: Problem with you girls is you don't hang out with the right sort. Me and Quasim know how to show a bird a good time – innit Kas?

QUASIM smiles, nervously.

And instead you choose to kick around the place with losers. Got no taste.

OMAR sits on the steps of the shop. He produces an apple and a knife from his pocket. He cuts the apple and eats it.

LUX: That's your opinion, shit-face, and this being a democracy, I guess you're entitled to it. Personally I wouldn't be seen dead hanging out with you.

QUASIM: What're you doing eating? We gotta get going.

OMAR: Gotta have my breakfast. By the way Lux. Who were you snogging yesterday? I saw you outside Oswald Mosley's classroom.

QUASIM: We all did.

LUX: Who asked you – fuck face?

TASLEEMA looks bemused.

TASLEEMA: Lux?

LUX looks awkward.

LUX: I was gonna tell you about him…

TASLEEMA: Who?

OMAR: Yeah, go on tell her. He had his tongue half way down her throat, cleaning her windpipes.

LUX: (*To TASLEEMA.*) The new boy – Fidel Anderson. (*Defiant.*) He's a great kisser.

OMAR: White trash.

LUX: He isn't actually. Lives in one of those big houses up on the hill. Father's a lawyer and mother's an artist.

TASLEEMA: So what's he doing in our school?

LUX: They're left wing or something weird.

TASLEEMA: You mean they've got principles.

LUX: Whatever.

QUASIM: You see what it says about you in the boys' loos?

LUX: I don't frequent the boys toilets.

QUASIM: 'Lux gives a great shine.'

LUX: (*To TASLEEMA.*) Didn't know the toad could read – did you?

TASLEEMA: Thought he was still going to those 'special classes'.

TASLEEMA and LUX laugh at QUASIM's expense.

OMAR: What's wrong with us?

LUX: You really want me to answer that?

TASLEEMA: Where do we start?

QUASIM: Kissing, kissing…disgusting.

OMAR: Revolting. Fucking whore.

TASLEEMA: Piss off.

LUX ignores the boys.

OMAR and QUASIM stand – arms around each other's shoulders.

OMAR: You should have more respect for yourself. Bit of dignity.

QUASIM: Bit of dignity.

OMAR: The whole school saw you.

QUASIM: We all saw you.

TASLEEMA: (*To QUASIM.*) What are you? A fucking parrot?

OMAR: You leave my brother alone.

TASLEEMA: He's not your brother.

OMAR raises his clenched fist in the air.

OMAR: Muslim Brethren.

QUASIM copies OMAR and raises his fist.

LUX: Here we go…

OMAR: United we stand to protect our sisters.

LUX: Under your definition I don't count as a 'sister'. I'm Hindu – remember?

OMAR: Yeah – I feel for ya – I really do. So me and Quasim here we've decided to include you. Take you under our wing so as to speak.

LUX: Spare me the honour.

OMAR: Your dad know what you get up to?

LUX: Your uncle know what you get up to?

TASLEEMA: Tosser.

QUASIM tries to pull OMAR on.

QUASIM: Come on Omar – we'll be late.

OMAR: Hold up. (*To LUX.*) You should stick to your own kind – innit. Don't want no dilution of the race.

LUX: Fascist.

TASLEEMA: What race?

QUASIM: The Asian posse race.

LUX: Half-wit.

OMAR: You lot fuck about with white boys and we'll all disappear. Impure blood – don't want that do we? Lose everything then – our identity, respect, culture.

LUX: Oh right. Let me get this straight. It's not okay for us to have white boyfriends but it's okay for you to sniff around every blonde slag you can get your filthy paws on.

OMAR: It's different innit?

TASLEEMA: How's it different?

OMAR: You are the mothers of the future.

TASLEEMA: And you're just a hypocrite.

OMAR: I'm a man. Can't help the call of a beautiful woman. Know wot I mean?

LUX: Yeah… Only no beautiful woman would want to go near you – pond life.

OMAR: Who are you calling pond life – slag?

QUASIM: Omar is right. You should be careful 'cos…

TASLEEMA: (*To QUASIM.*) What are you going on about anyway? Your mum's English.

QUASIM: Yeah, but she converted.

LUX: But that don't change her skin colour. She's white, if anyone's fucking diluted 'round here, it's you.

QUASIM looks upset.

OMAR: Hey, easy, going a bit below the belt now.

LUX: (*To QUASIM.*) It won't rub off on you dog breath.

TASLEEMA: You're better off as you are.

LUX: Hanging around with shit-face isn't going to make you Bengali.

OMAR: He wants to be with his own kind, so back off. Go on Quasim, continue with what you were saying before you were so rudely interrupted.

QUASIM hesitates.

Go on!

QUASIM: These white boys – they'll take your maidenhood and then chuck you – like rubbish.

LUX: Maidenhood?

TASLEEMA: You do know you're talking to Lux. She's no virgin.

LUX: No. I'm a Sagittarius.

The girls crack up. QUASIM looks confused. OMAR looks annoyed.

OMAR: You'll be laughing on the other side of your faces when no respectable Asian man wants to go near you.

TASLEEMA and LUX slap palms jubilantly.

TASLEEMA: Result!

The girls laugh more.

OMAR: You'll end up like Tas's sister.

TASLEEMA: Leave Nasreen out of this.

OMAR: Is that what you want? To be outcast? On the scrap heap? It's bad enough with your mum in the nuthouse.

The girls stop laughing.

TASLEEMA: Piss off Omar.

OMAR: And I heard your sister's living in a damp bedsit with no money and no food to eat and she gets fucked every night by her white trash boyfriend and all his mates.

TASLEEMA looks upset. LUX pushes OMAR. OMAR lunges forward but QUASIM gets in the way.

QUASIM: Hey. We don't hit girls.

TASLEEMA: You wash your mouth out, bastard.

OMAR: Truth hurts doesn't it? If you're not careful, you're gonna end up like her. (*Points at LUX.*) A white man's slag…

This time TASLEEMA pushes OMAR violently. He falls to the floor but springs up and looks dangerous. HASSAN enters. He clocks the situation and rushes forward.

HASSAN: (*Accent.*) Hey. What's going on here?

He stands between TASLEEMA and OMAR.

OMAR: (*Glaring at the girls.*) Nothing. Apart from our women have forgotten their place.

LUX: What? On our knees and our backs?

TASLEEMA: Get it into your twisted, nasty little brain – we ain't your women.

HASSAN looks menacingly at OMAR and puts his arm around TASLEEMA.

HASSAN: If I ever see you hassling these girls again, or showing them disrespect, I will be after you Omar.

OMAR changes tack.

OMAR: Come off it Hassan – bro. It was just a disagreement. No worries.

OMAR blows each of the girls a kiss and smiles and waves sweetly at them as he exits.

Kas. Time for our prison exercises.

QUASIM looks apologetically at the girls and follows OMAR out.

LUX: One day, that bloke's gonna get it in the neck.

TASLEEMA: Little git.

HASSAN holds TASLEEMA.

HASSAN: Are you okay?

TASLEEMA: Fine. Nothing me and Lux can't handle.

HASSAN: I thought he was going to hit you.

TASLEEMA: He wouldn't dare.

LUX watches as the two hug briefly. She looks bored. TASLEEMA's phone rings. She fishes it out of her bag and answers it.

Hello? Abba? Yeah… I've got a free lesson first period but I've gotta switch my phone off now. You know the rules. I'm heading to school now…the library – yeah – I'll come straight home after. Okay. Yeah.

She hangs up.

HASSAN: That your father again?

TASLEEMA: Yeah

LUX: He's keeping a close eye.

HASSAN: You'd better get to school.

TASLEEMA: But, I've got a free period – I thought we could…?

HASSAN: I'll pop over in your lunch break. Meet you in café across the road?

TASLEEMA: Alright then.

TASLEEMA leaves reluctantly. LUX gives HASSAN a dirty look and follows her out. HASSAN watches them go. He pulls out a comb from his back pocket and carefully combs his hair and then exits.

Scene 2

Outside Ladoo.

We are back outside 'Ladoo'. It is after school.

LUX enters with FIDEL. He is a white youth, the same age as LUX – casually dressed.

FIDEL: (*Manchester accent.*) Ain't you gonna introduce me to your parents then?

LUX: You must be joking.

FIDEL: You ashamed of me?

LUX: No.

FIDEL: I want you to meet my parents.

LUX: Yeah, but mine'll freak out. They're still living in the dark ages – forgotten that the world and the human race have moved on.

FIDEL: (*Ali G style.*) Is it 'cos I is white?

LUX: No.

FIDEL: What then?

LUX: It's 'cos you're a boy.

FIDEL : I can't help that. (*He laughs and looks at the sweet shop.*) My mum and dad love this shop. Always popping in here to buy pakoras, samosas, onion bhajis.

LUX: Your fossils sound dead cool.

FIDEL: They're fucking posers. Mind you, they'll love you.

LUX: (*Pleased.*) You reckon?

FIDEL puts his arms around LUX.

FIDEL: A real live Indian. Talk about cheap thrills. Dad'll probably wet himself. 'Course he'll bore you shitless with all his stories of backpacking 'round India.

LUX: Probably seen more of it than I have… Oh, I worked out what you said.

FIDEL: Eh?

LUX: Ami tomake bhalo bashi.

LUX giggles.

I didn't understand it at first, so I asked Tas.

FIDEL: Can't you speak Bengali?

LUX: No. My family are from South India. We speak Tamil.

FIDEL looks embarrassed. LUX laughs.

FIDEL: Should've known that.

LUX: Yeah, you should've.

FIDEL tries to kiss LUX. She pushes him away.

FIDEL: What have I done now?

LUX: Someone might see…

LUX looks around her surreptitiously.

Get reported straight back to the fossils.

FIDEL: You're so uptight.

LUX: You don't know what it's like. One false move and I'll be stacking shelves in our shop for the rest of the year.

FIDEL: You're always looking over your shoulder.

LUX: That's because this place isn't safe. Full of twitching curtains.

FIDEL sits on the step.

FIDEL: My folks are going away tonight.

LUX: Yeah?

FIDEL: Got the house all to myself.

LUX: (*Grins.*) Yeah?

FIDEL: It gets very lonely in that big house all on my own.

LUX: I ain't fallling for that one.

FIDEL: Thought you might want to keep me company.

LUX looks away anxious.

I could cook you a meal.

LUX: Can you cook?

FIDEL: Oh yeah. Mum's been teaching me since I was ten. Says she doesn't want me to be a burden on my future girlfriend.

LUX: She's so cool your mum.

FIDEL: Bit of a naked chef with the old ingredients me.

LUX is impressed.

You should come and try out my coq au vin.

LUX: Dirty bastard.

FIDEL: It's a French recipe – Chicken with wine.

LUX looks at FIDEL, uneasy.

LUX: I ain't an easy lay.

FIDEL: Never said you were. Just inviting you to dinner.

LUX: Not sure I'll be able to get away.

FIDEL: Let me know – give me a chance to shop.

LUX looks at FIDEL slightly incredulous.

TASLEEMA enters. She is in a panic, clutching a letter. She stops when she sees FIDEL. She looks at FIDEL and then back at LUX.

Wotcha.

TASLEEMA: (*Cold.*) Alright.

LUX looks uncomfortable, as there is an awkward silence. FIDEL takes the hint.

FIDEL: See you around.

LUX: Yeah – catch you later.

FIDEL exits.

TASLEEMA: What was he doing here?

LUX: Nothing. Just chatting.

TASLEEMA: You ain't getting serious with him – are you?

LUX: No.

TASLEEMA: He's a white boy.

LUX: No? Really?

TASLEEMA: What're you doing hanging around with a white boy?

LUX: What's it to you?

TASLEEMA: I don't like the look of him.

LUX: Like I give a shit. Anyway, the Asian blokes round here are useless. Only future for them is working in their uncle's restaurant. Fucking losers the lot of them.

TASLEEMA: That's why you're hanging out with the 'Cuban missile crisis'?

LUX: You're getting like Omar.

TASLEEMA: Don't start thinking those white boys are any better, 'cos they're not. They're all the same. Only after one thing.

LUX: Except for Hassan of course, who's God's gift to…

TASLEEMA: Hassan's different.

LUX: How?

TASLEEMA: He's more mature, he's caring and he…

LUX: He ain't good enough for you and I don't trust him.

TASLEEMA: That's my lookout.

LUX: He really fancies himself. Always fussing with his hair whipping out his comb from his back pocket every five minutes.

LUX mimics HASSAN combing his hair. TASLEEMA can't help but crack up.

TASLEEMA: He is a bit vain.

As the laughter subsides, TASLEEMA looks away.

LUX: What's the matter with you anyway?

TASLEEMA looks down at the letter in her hand.

TASLEEMA: I found this e-mail at home. It was still up on the computer screen…

LUX takes the letter and reads it.

It's from my dad to my uncle in Dhaka. Look.

Beat.

He says he can't cope, with Amma being in hospital. Says I'm a handful…wants to know if I can go and live with them.

LUX looks up from the letter, bemused.

LUX: Is your mum having an operation?

TASLEEMA: He won't admit to anyone she's in a psychiatric hospital will he? Just making up some huge fib to the rellys.

LUX: He won't do it.

TASLEEMA's mobile phone rings. She picks it up.

TASLEEMA: Abba? Yeah…okay, I'm outside Ladoo – getting some samosas. No, I'll be back soon…yeah Abba…I won't be late. I promise.

TASLEEMA hangs up.

Fascist.

TASLEEMA looks away anxious.

I look at those white girls in our class and I wonder what it must be like to have so much freedom. No rules, no God, no fossils breathing down your neck all the time...imagine.

LUX: At the end of the day, they have the same problems.

TASLEEMA: How's that?

LUX: It's like the tortoise and the hare. White girls have a have a head start – but in the end, it doesn't work out any better for them.

TASLEEMA: 'Sppose.

Beat.

I combed Amma's hair this afternoon.

LUX: You went to see her? You never said.

TASLEEMA: It's her fortieth birthday. I spent an hour just combing her hair.

LUX: She say anything?

TASLEEMA: No.

LUX: Nothing?

TASLEEMA: Not a single word. Doesn't seem to be getting any better. Sometimes, I think she's never coming home. Abba'll just marry me off to get rid of me – then he won't have any women to worry about.

LUX: You know something?

TASLEEMA: What?

LUX: You can be really fucking depressing sometimes.

TASLEEMA: What if he really does send me back Lux?

LUX: He won't.

TASLEEMA: How can you be so sure? Look at this letter!

LUX tries to make the best of things.

LUX: You're going to be eighteen in two weeks time, we're gonna have a party, we're gonna celebrate and then we'll see…

A football is kicked on, followed in hot pursuit by OMAR. He dribbles and kicks the ball around, generally showing off, dodging in and out between the girls with the ball.

Oh God, here we go.

OMAR: (*Commentating as he plays.*) Look at that beautiful run with the ball…the sheer skill and brilliance of this young player – the first British born Muslim ever to have made it into the World Cup squad. He's weaving past Ronaldo and Ronaldino. Oh look at that! A lovely dummy – he's on the edge of the box, he's dribbling past the last line of defence – only the keeper to beat…can Omar Khan turn around forty years of English football history? Oh yes!

OMAR lobs the ball. It crashes into a display window of 'Ladoo' and shatters the glass.

OMAR stands guilty and aghast.

Scene 3

TASLEEMA's dream.

TASLEEMA is huddled up in a dark box like space. She cannot stand up or lie down. She is terrified as we hear the sound of a car's ignition starting up and we realise she is in the boot of a car. She bangs loudly on the side of the car shouting in desperation.

TASLEEMA: Abba! Abba! Let me out. Where are you taking me?

The car starts to move.

I have to see Amma. You can't force me to leave. Where are you taking me? Please Abba. Let me at least finish school, let me take my exams…you can't make me… I don't belong there…this is my home… Abba…don't force me onto that plane.

We hear the car accelerate. TASLEEMA settles for a moment and then bangs again on the side of the boot in utter desperation.

Abba – don't do this to me. Please.

She cries.

Let me out! Let me out! I can't breathe. Abba – I'm suffocating.

TASLEEMA's voice echoes and then fades out.

Scene 4

Outside Ladoo.

It is later – evening. OMAR is sweeping up the scattered glass. QUASIM sits and watches.

OMAR: (*To QUASIM.*) Come on man – you could at least give me a hand. I need some help here.

QUASIM reluctantly holds open a bin liner for OMAR to shovel the broken glass into.

QUASIM: You heard what happened at school today?

OMAR: No… I bunked off this afternoon. Double maths with 'Crater Face' was too much for me to handle.

QUASIM: There was a fight…

OMAR: So what's new?

QUASIM: It was heavy. White kid got cut up.

OMAR: Who?

QUASIM: Mike Stevens.

OMAR: He's a bastard.

QUASIM: Got stabbed in the hand.

OMAR stops sweeping for a moment and looks at QUASIM, anxious.

Coppers piled in and everything.

OMAR: They caught someone?

QUASIM: Yeah – Agron.

OMAR looks worried and upset. QUASIM watches him carefully.

They've arrested him.

OMAR: Shit. Why didn't you tell me this before?

QUASIM: I just have.

OMAR: This is serious. Shit man.

HASSAN enters. He is carrying some wooden boards and a tool box. He surveys the shop front.

HASSAN: (*Accent.*) Must have kicked that ball pretty hard to shatter this.

OMAR: Hassan, what's up bro?

HASSAN: Your uncle phoned. Needs me to board up the windows until tomorrow.

OMAR: He thinks some desperate type's gonna loot his ladoos?

QUASIM laughs.

HASSAN puts the boards down. He pulls out a comb from his back pocket and combs his hair quickly before getting to work.

OMAR: Uncle's a tight arse. Even the shop front window's bought budget in the Paki cash and carry.

HASSAN: You're definitely not Mr Happy today.

HASSAN starts hammering up the boards.

OMAR: He's gonna make me pay for it. Got to work in that pit for a whole month at the weekends. And he's a fucking slave driver. Bet the bastard writes to my parents complaining.

QUASIM: Keep your voice down, he might hear you.

OMAR: I ain't scared of him. I could tell he wanted to hit me.

HASSAN: If your father was here he would probably beat you.

OMAR: My Abba ain't like that.

HASSAN: Then you are lucky. Your father not beat you and neither does your uncle – so why you complaining?

QUASIM: There's violence behind my uncle's eyes. I can see it.

HASSAN: It's probably only when he looks at you.

OMAR: Fuck off Hassan.

HASSAN laughs.

It's not funny. He hates me man.

HASSAN: He does not.

OMAR: Whose fucking side are you on?

HASSAN: Yours. But you are talking like a fool. Always imagining things huh? Uncle hates you, girls hate you, Maths teacher wants to kill you. You have big problems inside.

HASSAN taps his head. QUASIM laughs.

QUASIM: He's paranoid all right.

OMAR: Shut it.

HASSAN: You must calm your blood.

OMAR: My parents fucked off back to Bangladesh and dumped me with a fascist uncle in an alien country which doesn't want me either. Nobody wants me.

HASSAN: I have the same feeling. Two years we have been waiting to see if we can stay in this country. Appeals and more appeals…

OMAR: It's for my good apparently – so I can get a 'decent' education. If it's for my education, send me to a proper school, one without fucking gangsters in the playground, somewhere with proper teachers who give a fuck.

HASSAN: My father says London is a city of opportunity.

OMAR: That's why he's working 'round the clock as a cabbie at 'Taliban Taxis' and you're doing odd jobs outside college for peanuts?

HASSAN: At least we're alive.

OMAR: There's alive and there's living – innit?

HASSAN: You have a good point. But we have to work hard to get on in this world.

OMAR: You're just like us Hassan, driftwood, scum floating on the surface.

HASSAN: Omar – please…don't include me in your madness.

OMAR: D'you know sometimes I feel like I'm like a suitcase…

QUASIM: Eh?

OMAR: No seriously. A suitcase full of amazing things that used to belong to someone. But like, I got lost on a flight and now I'm shunted from one airport to another. No one wants to claim me and no one wants to open me. An unwanted piece of baggage full of wonderful possibilities.

HASSAN: What amazing things are in your suitcase?

QUASIM: Women's lacey knickers.

OMAR: Maybe in your suitcase, turd-brain. But in mine, there are like maps of the world, old ones and telescopes and beautiful crystals and…treasure…stuff like that.

QUASIM: All off the back of a lorry.

HASSAN: Very poetic.

QUASIM: Fucking headcase.

OMAR gets bored with the sweeping.

OMAR: This is such a waste of time. The shit. Way he was behaving, you'd think I did it on purpose.

HASSAN: You broke his shop window, glass everywhere, in the sweets – he lost a lot of money.

OMAR: So? It's only a broken window. Uncle should be grateful I'm not like one of Mohammed's gang. You seen 'em?

HASSAN: It is sad.

OMAR: Fucking tragic. Smoking that evil rock, high as kites, always shitfaced.

QUASIM: I saw them on the way here; down dog shit alley. Scary bunch. They were off to do some damage.

OMAR: They come here every night, hang around outside the shop. Vicious bastards. Tried to rob uncle last Friday. He was coming back from the Mosque.

HASSAN: What happened?

OMAR: Uncle never goes far without his baseball bat. He waved it at them and they legged it.

OMAR looks at the broken glass.

At least I'm not high on crack. Uncle should be grateful. It could be a lot worse, I could be like all those losers.

QUASIM: Here, what happened to those sweets?

OMAR: He had to chuck 'em all – innit?

QUASIM: Are they in the bin?

OMAR: Why?

QUASIM: We could sell 'em at school.

OMAR: Don't be daft.

HASSAN: Some poor child could rip his throat up swallowing sweetmeats. That's a great idea.

QUASIM: We could make a lot of money.

OMAR: Give 'em to the teachers. Imagine the little bits of glass slashing their insides. Razors on guts. Innit?

QUASIM: Nice one.

OMAR and QUASIM share a laugh. HASSAN hammers up more boards.

QUASIM: Hey Hassan, you still with Tasleema?

HASSAN: Why you ask?

QUASIM: Interested, that's all.

OMAR: He's got the hots for Tas and he's hoping that if you've finished with her, he could have a go next.

QUASIM: Fuck off Omar.

OMAR: I'll ask her out for you if you want.

QUASIM: Get stuffed.

OMAR: So, how's it going with Tas?

HASSAN: Fine.

QUASIM: Have you shagged her?

HASSAN looks at QUASIM a little affronted.

Well?

Beat.

HASSAN: That is none of your business.

HASSAN turns back to his work.

OMAR: Don't you ever get fed up of this country Hass? I mean man, it's getting worse you know – with this war. They hate Muslims. The other day some little shit caled my auntie a 'Muslim Cunt'. They've even started picking on our women.

HASSAN looks sad.

HASSAN: Sure, I get fed up. But what is the alternative for me? Go back to Kabul and sift through the rubble? Even with all the aid they're supposedly pouring into my country, they cannot mend the damage their bombs did. The money is not enough to even begin to rebuild the houses and villages.

OMAR: We'd be better off fighting for Saddam. Least we'd know where we were.

HASSAN: That is not the solution.

QUASIM: Yeah man – You might get killed or worse still, locked up in a cage on that island. Gives me nightmares that place. All those men, chained up, shuffling around like zombies. Things that gets me is what if they're innocent? What if they done nothing?

OMAR: I wouldn't get caught. I'd die for the cause.

HASSAN: What cause?

OMAR: It's us against them. A holy war – that's what that Bush said.

HASSAN looks incredulously at OMAR.

They'd chain us all up like that if they got half the chance. Then they could get their hands on all the oil. Evil bastards.

HASSAN: Everyone is evil according to you Omar.

OMAR: Hassan man, I don't know how you can be so fucking noble. They destroyed your family.

HASSAN: If there's one thing I've learned it is this – evil men exist everywhere in the world. Only the children are innocent and they learn by example.

OMAR: Yeah man.

HASSAN: At the end of the day, you and I must make the best of things.

Scene 5

LUX is perched on the edge of the bed in FIDEL's bedroom. FIDEL is sat in a chair opposite her.

FIDEL: Where d'your parents think you are?

LUX: Gig at school.

FIDEL: What time d'you have to get back?

LUX: Ten.

FIDEL: So, we ain't got much time.

LUX: Much time for what?

FIDEL: You got a very suspicious nature.

LUX: Where've your parents gone?

FIDEL: Some friend of theirs in the country. Fiftieth birthday party. They'll be back tomorrow.

LUX: Don't you get scared here – on your own?

FIDEL: Scared? It can be a bit spooky. It's an old house.

LUX: So many rooms.

FIDEL: Yeah. Imagine how many families must've lived here through the years.

LUX: It's probably haunted.

FIDEL: Funny you should say that…

LUX: What? You haven't got ghosts here have you?

FIDEL: Never actually seen one…but there have been times…well, let's just say there's definitely something odd in the atmosphere.

LUX looks terrified.

LUX: You're winding me up.

FIDEL: Straight up. Mum fancies herself as a bit of a psychic. Says she's seen a little girl about two or three times – looks like she's from the 1920s. Says she can sometimes feel a kid holding her hand.

LUX: (*Terrified.*) How can you live here? A ghost? Fuck.

FIDEL: I ain't ever seen this kid. And to be honest, I reckon it's all those acid induced flashbacks mum gets. That and one too many G and T's before bedtime.

LUX looks scared. FIDEL sits next to her on the bed and puts his arm around her.

We cut to:

It is late. HASSAN and TASLEEMA are standing by the bus stop. They are holding hands.

HASSAN kisses TASLEEMA's hand. She smiles.

HASSAN: I wish I had money. Then I could take you out properly.

TASLEEMA: It doesn't matter.

HASSAN: I would like a car. Then we wouldn't always have to wait for buses.

TASLEEMA: Spend half my life here.

HASSAN: We could go for drives in the English countryside and look at all that green grass they have here.

TASLEEMA: (*Laughs.*) Can you drive?

HASSAN: Oh yes. In Kabul, we had a car, a nice house, books and even a little plot of land. My Ammi planted things.

TASLEEMA: You never talk about your mum much.

HASSAN: It is…difficult. My father is a broken man. He drives that cab, makes his money in complete silence. Doesn't talk to the passengers. When they ask him where he's from, he says he is Pakistani. I suppose he doesn't want to get into a conversation about the war.

TASLEEMA: He must miss your mum a lot.

HASSAN: Never talks about her. In the old days, he used to laugh a lot. Always making jokes. Not anymore. I feel as if sometimes, I am living with a ghost.

TASLEEMA: How long has it been?

HASSAN: Two years. I know he is thinking of her all the time. Her and home.

TASLEEMA: What about you? You think about it all the time?

HASSAN: I try not to. But sometimes, I wake up feeling afraid. You never can let go of the fear. If you saw a Talib walking down the street, you hid your face, you didn't look them in the eye. My uncle and auntie were walking past them once and her ankles were showing under her burka. They beat them both with sticks. Blood everywhere. The vice and virtue police they called themselves.

TASLEEMA: Did they kill them?

HASSAN: She survived but he died.

TASLEEMA: Just for showing her ankles?

HASSAN: I must move on with my life. I must not live in the past. I have a new beginning and I have you.

HASSAN puts his arms around TASLEEMA and kisses her.

I am a lucky man. You are the girl of my dreams.

TASLEEMA: What are you on?

HASSAN: I think we have a future.

TASLEEMA: Yeah?

We cut to:

Inside Ladoo.

It is late – night. We are now inside the sweet shop. QUASIM and OMAR are sat on the floor giggling. OMAR is rolling a joint.

OMAR: She was beggin' me.

QUASIM: Straight up?

OMAR: Crying, saying she loved me and all that kind of shit.

QUASIM: Nah – man…

OMAR: If you don't believe me, ask Eno. He was there. It was kind of sad – I actually felt sorry for her. Desperate she was.

QUASIM: She's really fit. Why d'you dump her?

OMAR: All got a bit heavy.

QUASIM: How heavy?

OMAR: Wanted commitment.

QUASIM: What? Like wanted you to get married?

OMAR: No – not that heavy.

QUASIM: So – what?

OMAR: You know what some girls are like.

QUASIM doesn't really know.

QUASIM: Yeah.

OMAR finishes rolling his joint and lights up. QUASIM looks a little worse for wear.

I don't think I can do no more of that stuff.

OMAR: Lightweight. Cripple toke.

QUASIM: My head's spinning.

OMAR: Faggot.

QUASIM: (*Getting angry.*) I ain't a faggot!

> *QUASIM tries to stand up, affronted. OMAR pulls him down again. QUASIM stumbles back down in a heap.*

OMAR: Keep your fucking hair on. You got no sense of humour Kas.

> *OMAR drags heavily on the joint and then passes it on.*

> *QUASIM drags gingerly on the joint and then coughs and splutters.*

QUASIM: Agron's in deep shit.

OMAR: Poor sod.

QUASIM: He shouldn't have stabbed that kid though.

OMAR: Nah.

QUASIM: That geezer could've lost his finger or even his hand.

OMAR: He just nicked it – nothing serious. Way the pigs are going on, anyone'd think he was psycho innit.

QUASIM: I think he's scary man.

> *OMAR looks thoughtful.*

OMAR: Kas – can I trust you?

QUASIM: Sure man. We're brothers.

OMAR: I'm gonna tell you something but you better not squeal or…

QUASIM: I won't tell no one.

> *Beat.*

OMAR: It was my knife – innit.

QUASIM is silent.

I lent it to Agron. He was getting bullied by that white gang – Mike Stevens and his cronies. You know what they're like – roughing him up, stealing his cash, calling him nasty names and he could hardly speak English. Felt bad for him innit? So, I loaned him my knife. I said, only use it in an emergency. Actually I said don't use it, just wave it around and it'll frighten them off.

QUASIM: If they find out it's your knife…

OMAR: Agron's safe. Just got spooked by those white bastards. He won't sell out on me.

QUASIM: They charged him with grievous bodily harm and possession of a weapon with intent to harm.

OMAR: Alright man – change the subject. You're depressing me.

We cut back to:

FIDEL's bedroom.

LUX and FIDEL are sat on the bed together. FIDEL looks as if he's planning to get make a move but LUX is still preoccupied with the ghost.

LUX: What's she look like?

FIDEL: Eh?

LUX: This ghost?

FIDEL: I dunno.

LUX: She look happy or sad?

FIDEL: I dunno.

FIDEL starts to kiss LUX's neck tenderly.

LUX: Maybe she's trapped. I saw a film once where this kid was murdered in the bath by his step-dad and his soul couldn't rest until his murder was avenged.

FIDEL is kissing her face. LUX stands up. FIDEL looks frustrated.

We're on our own in a bloody haunted house?

FIDEL: It's my mum. I told you what she's like.

He reaches out to her. LUX hesitates before sitting next to him. They kiss. LUX relaxes a bit. As they part, LUX lies in FIDEL's lap. He strokes her hair.

LUX: Thanks for dinner.

FIDEL: My pleasure.

LUX: I was well impressed.

FIDEL: That was the idea.

He kisses her again.

You saved my life.

LUX: When was that?

FIDEL: Left everything behind. People I used to hang out with, old haunts…to come down to the 'Smoke'.

LUX: Fidel missing home?

FIDEL: I'm all on me own here. Sister's ten years older than me – she works in Leeds now – and me parents are always out saving everyone's lives…never have time for me.

LUX: Ahhh…poor lost Fidel.

They kiss again. As they part, LUX giggles.

FIDEL: What?

LUX: If my fossils could see me now.

FIDEL: They must have some idea?

LUX: Must be joking.

FIDEL: They think you're a paragon of virtue?

LUX: 'Course they do. And as long as they think that – I'm safe. Limited freedom's better than none at all. My cousin got caught with a bloke last summer. It was like World War Two. You wouldn't believe the weeping and wailing that went on. Like someone had died.

FIDEL: But surely your folks can't be that naive. I mean Asian girls, they're not exactly the shy retiring types are they?

LUX: What d'you mean?

FIDEL: I mean, they all play-act the innocent but get them on their own and…

LUX: How many Asian girls you been with then?

FIDEL: I didn't mean…

LUX: Come on tell me about Asian girls. Since you're such an expert. I wanna know.

FIDEL: All I'm saying is that – it's a stereotype and you all play to it. I've seen it before. Strict parents, obedient little daughters and all of you lying your heads off – bunking off school, going out with blokes behind your parents' backs.

LUX: That's how we get by.

FIDEL: Seems dishonest – that's all.

LUX: Yeah well. Some of us don't have a choice.

We cut to:

Bus stop.

TASLEEMA and HASSAN are standing at the bus stop.

HASSAN: How is your father?

TASLEEMA: Same as ever. Locked me in my bedroom tonight. He's been doing that for a week now. Have to piss in a pot under my bed. Unlocks it again in the morning.

HASSAN: You escaped through the window?

TASLEEMA: Like I always have. Should see me shinning down that drain pipe. I'm like fucking Spider-man.

They laugh.

HASSAN looks serious.

HASSAN: It is not good that he locks you up.

TASLEEMA: Thinks I'm gonna run off like Naz. I'll be eighteen in a couple of weeks time – then I can make my own decisions. He can't control me.

HASSAN: Maybe I should speak to him.

TASLEEMA: No.

HASSAN: If he met me.

TASLEEMA: No.

HASSAN: Why not? I am Muslim. I am from the same part of the world. Maybe he would look on me favourably.

TASLEEMA: No – he wouldn't. You don't know my Abba. He doesn't listen to reason.

HASSAN shrugs. He puts his arm protectively around TASLEEMA.

He doesn't realise how awful he is. Thinks he's doing it for my good.

HASSAN: Do you hate him?

TASLEEMA: Yeah…no… So tired of having to think up excuses. Doesn't even want me to visit Amma. Doesn't want me to see her in 'that state' as he calls it.

HASSAN: Why?

TASLEEMA: He thinks it's undignified. She's traumatised, he's in a state and all he can think of is dignity. There is no fucking dignity in a situation like this. The only way I can get to see her is during the day, when I should be at school. Carole Jones – my English teacher – she's great. I told her everything. She was very understanding. She lets me go. Basically turns a blind eye when I bunk off in the afternoon. Every night I dream I'm locked in the boot of a car – being driven to somewhere…

HASSAN looks at TASLEEMA and holds her tight.

HASSAN: I won't let that happen to you.

They hug and kiss.

TASLEEMA: Why are the rules different for women? Why should we be imprisoned like this?

HASSAN: My Ammi used to say the same.

TASLEEMA: He forces me to lie. If he just trusted me, things would be different. It's almost like he's afraid of letting me exist as a human being in my own right. No wonder my Amma went…she doesn't even recognise me when I go and visit her.

HASSAN comforts TASLEEMA.

Used to be able to talk to her about things…now it's like I'm invisible.

We cut to:

Inside Ladoo.

OMAR and QUASIM.

OMAR gets up and wanders around the sweet shop.

OMAR: My little fucking empire. Uncle's got no kids see –
so I stand to inherit all this. Ladoos, gulab jams,
rosogollas, jelebis, samosas, pakoras…

QUASIM: Cool.

OMAR: Yeah – something to look forward to – innit? A
lifetime of slaving away behind the till, making sweets,
never seeing the light of day, stuck in the kitchen all the
time with a bubbling vat of sweet gooey stuff.

QUASIM: So what d'you want to do?

OMAR: Dunno. You?

QUASIM: Wanna be a vet.

OMAR: You what?

QUASIM: I like animals.

OMAR: Cats and dogs and that kind of thing?

QUASIM: Yeah.

OMAR: That's well weird. I ain't knocking it – just thinking
– it's like quite specific isn't it?

QUASIM shrugs.

Know what you wanna do and go for it. Cool. What
happens if you have to deal with a sick pig?

QUASIM: Eh?

OMAR: You can't touch a pig can you? It's haram.

QUASIM: I hadn't thought of that.

QUASIM hands the joint back. He looks around the shop.

Munchies.

OMAR: Help yourself.

QUASIM: Where's your Unc?

OMAR: Gone to the East End. Some knees up with his cousins. Don't worry, he won't be back for hours yet. Probably all sitting around complaining about us.

QUASIM: He's alright your uncle.

OMAR: He's a tosser.

QUASIM staggers around the shop and looks at the various sweets. He peers closely at the laoos.

Gotta pass my GCSEs this time 'round, else I'm fucked. Then maybe I'll go to business school. Fancy myself as a wheeler dealer. Wear sharp suits, go to flashy night clubs, spend my dosh in high class places like…like…Nicole Farhi. (*He giggles.*) Far cry from the fossils. They'll look at me and say – 'See that smart geezer? One who lives in that swish apartment – that's our boy.'

On the other hand – can't help thinking – what's here for me? Maybe I should've gone back to Sylhet. Ain't seen my little sister in three years.

QUASIM: What's out there for ya?

OMAR: Dunno.

QUASIM picks up a ladoo and stares at it in horror. He throws it on the floor – afraid.

Hey, have some respect man. Don't chuck the munchies around.

OMAR notices QUASIM's frightened look.

We cut back to:

FIDEL's bedroom.

FIDEL watches LUX for a moment and then starts to unbutton his shirt. LUX watches him. He grins and takes off his shirt, patting the bed next to him.

LUX: What d'you think you're doing?

FIDEL: Thought we could have a bit of inter cultural exchange.

LUX: I told you. I ain't an easy lay.

FIDEL: Why d'you come here then?

LUX: I came here 'cos I thought you were different.

LUX picks up her bag and jacket and heads towards the door.

FIDEL: I'm sorry – Lux – don't go –

LUX hesitates by the door. But she is still angry.

LUX: I'd walk out on you, down them stairs and out the front door…but I don't want some fucking ghost kid trying to grab my hand in the hallway.

FIDEL: You could always sing her a nursery rhyme. Mum says she particularly likes 'Twinkle, twinkle, little star…'

LUX: Fidel!

FIDEL laughs. He puts his shirt back on quickly and approaches LUX.

FIDEL: Look, I'm sorry. Didn't mean to upset you like that. I'll make you some coffee, then I'll walk you home. Allright?

LUX is sulking. She nods.

I really do like you – a lot.

LUX: And I like you. So let's just…take it slow.

FIDEL: Okay.

We cut to:

Bus stop.

TASLEEMA and HASSAN are kissing.

A mobile phone starts to ring. TASLEEMA finds her phone in her bag. She fishes it out and looks in horror at the number flashing up on the phone's screen.

TASLEEMA: Shit.

HASSAN: What?

TASLEEMA: It's Abba. He must have found out I'm not there. Shit.

TASLEEMA looks distraught.

We cut back to:

Inside Ladoo.

OMAR and QUASIM.

QUASIM is staring in horror at the sweets.

OMAR: What's up?

QUASIM: Look at them all.

OMAR: What?

QUASIM: They've got faces.

OMAR: What have?

QUASIM: The ladoos. Look like pimply, evil demons…

OMAR: Yeah right.

QUASIM: I swear. They're all grinning at me.

QUASIM surveys all the ladoos on display with equal horror. He turns his attention to the samosas.

And look at those fuckers.

OMAR starts to giggle.

I can see through them. They're like pyramids. Fucking pyramids with things inside them…mummies.

OMAR laughs more.

This is serious Omar.

QUASIM recoils from the samosas. He looks terrified.

OMAR: It's the spliff man.

QUASIM: No, no, it's real. It's real. They've all turned into…

OMAR: Calm down.

QUASIM reels. OMAR has to steady him.

QUASIM looks around at the sweets again.

I'll get you some water.

OMAR exits. QUASIM looks afraid. The lights change so that we know we are now in QUASIM's dream. The sweets all light up and start to speak to him.

FIRST LADOO: Problem with you Quasim is your half and half innit?

SECOND LADOO: Impure blood.

THIRD LADOO: Only thing about you that's Muslim is your name.

QUASIM: I'm trying.

FIRST SAMOSA: Oh, he's trying.

The SAMOSAS light up and laugh uproariously.

SECOND SAMOSA: You're a dilution of the original, a pale copy.

THIRD SAMOSA: No one really wants you. The English think you look weird and the Muslims think you're a fake.

QUASIM: I ain't a fake. I'm the new blood. The future belongs to people like me – mixed races, dual identity, double heritage…

FIRST SAMOSA: You hear that boys? He's part of the new – super human race.

The sweets all laugh.

QUASIM: Leave me alone! I am who I am.

FIRST LADOO: You're a very naughty boy, that's what you are. We know you've been having dirty thoughts.

SECOND LADOO: A certain young lady called Tasleema.

THIRD LADOO: If she could read your thoughts when you're standing next to her, she would blush.

QUASIM: Stop it.

FIRST SAMOSA: We saw you in your bed last night. Tossing off over her.

QUASIM: Shut up!

SECOND SAMOSA: Little squirt.

THIRD SAMOSA: Half-caste twit.

FIRST LADOO: Mummy's boy.

SECOND LADOO: Still sucks his thumb at night.

THIRD LADOO: Probably wets his bed.

FIRST SAMOSA: And he's a traitor. Muslim Brethren indeed.

QUASIM: Shut up!

QUASIM curls up into a ball in the corner of the room. The sweets continue to laugh at him. He looks upset.

Scene 6

Bus stop.

It is morning. LUX is waiting outside the bus stop. She is waiting, looking at her watch – impatient. A dishevelled OMAR saunters up.

OMAR: What's up Lux?

LUX ignores him.

Oh come on babe…

LUX: Don't babe me you toe rag.

OMAR: You love me really.

LUX: In your wet dreams.

OMAR: Very funny.

LUX: Where's your sidekick?

OMAR: You mean Quasim?

LUX: Who else?

OMAR: Not well. Had a bit of a sesh last night. He went green and spent the whole night throwing up. Had to ring his big bro up to come and take him home.

LUX: Poor sod.

OMAR: Can't quite swim with the big fish yet.

LUX: What were you smoking?

OMAR: Some wicked shit. Want some? I got ten quid bags.

LUX: Let's have a look.

OMAR produces a bag from his school bag and shows it to LUX. LUX looks at it, almost disinterested, expertly rolls it in her hand and sniffs it.

LUX: Smells like good stuff.

OMAR: It's more than good. Gotta go easy on it, else you start tripping like mad.

LUX looks away and surreptitiously produces £10 and hands it over to OMAR whilst pocketing the bag.

Got it off a yardie.

LUX: They carry guns.

OMAR: Don't worry about me babe, I can look after meself.

LUX: You carry that stuff 'round in your bag?

OMAR: It's safe babe.

LUX: Will you stop calling me babe? Anyway, you should be careful. They've started checking our bags at school after that fight.

OMAR: I've got a secret place to stash the gear. No worries.

LUX: I hope you know what you're doing

QUASIM enters looking sick.

OMAR: Whatsup Kas. You're late man. Didn't get my morning call.

OMAR rather cruelly slaps QUASIM on the back.

QUASIM: (*Groans.*) Ohhhh…

OMAR: Still seeing yellow demons?

QUASIM: Fuck off.

OMAR: Thought I was gonna have to walk all the way to school on me own. (*To LUX.*) Coming?

LUX: Wouldn't be seen dead walking with you losers.

OMAR: The feeling's mutual – cow.

LUX: Inch dick.

LUX waggles her little finger at OMAR.

OMAR: You wanna look? You just gotta ask.

He makes as if he's going to flash his dick at LUX.

LUX: Euch – put it away!

OMAR and QUASIM laugh and exit.

OMAR: Such a bitch.

QUASIM: You're still dying to get in her knickers though.

OMAR: Shut it.

TASLEEMA enters. She looks distraught – and dishevelled. LUX is horrified.

LUX: Tas! Look at the state of you! Where've you been? What happened?

TASLEEMA: It's Abba – he's gone mad.

LUX: What'd he do?

TASLEEMA: I thought he was going to kill me…

LUX: Sit down, calm yourself – tell me…

LUX helps TASLEEMA to sit down.

TASLEEMA: I slipped out last night…he'd locked me in my bedroom…

LUX: You go to the gig?

TASLEEMA starts to cry.

Tell me…it can't be as bad as all that.

TASLEEMA: It is. It's awful. I'm in deep shit. Up to my neck. Can't tell Amma, 'cos she's not…he's gonna…oh God… Lux, what am I gonna do?

LUX: Did he slap you around?

TASLEEMA: No. Just screamed and screamed at me. He was so upset. He was crying.

LUX looks a little helpless.

LUX: So, what exactly did he say?

TASLEEMA: He's sending me back.

LUX: To Bangladesh?

TASLEEMA: He's going to his travel agent today to buy a ticket.

LUX: Shit.

TASLEEMA: No more school. That's it.

LUX: He can't do that.

TASLEEMA: He won't listen…if Amma was around, she'd stop him but…

LUX: We have to think…we can fix it.

TASLEEMA: How?

LUX: There's a law against forcing girls on a plane. We could go to the Police… He can't send you back.

TASLEEMA: He'll force me.

LUX: You can shout and scream at the airport. Say he's taking you against your will. Make a scene.

TASLEEMA: He's my father. How can I betray him like that?

LUX: Hasn't he betrayed you?

Beat.

Where'd you go last night anyway?

TASLEEMA: Hassan. We went to the flicks.

LUX: I hope he was worth it.

LUX frowns, in thought.

Maybe you could run away.

TASLEEMA: I don't want to end up like Naz.

LUX: Maybe it's the only way.

TASLEEMA: On the run? Always looking over me shoulder? Cut off from everyone I know? What kind of a life is that?

LUX: It's better'n no life at all.

LUX looks lost. TASLEEMA is distraught.

ACT TWO

Scene 1

Outside Ladoo.

It is later in the day. FIDEL is sat on the steps of 'LADOO' eating some sweetmeats. He watches out for LUX.

HASSAN enters. He nods at FIDEL but waits some distance away. They are silent for a while. HASSAN looks anxiously out for TASLEEMA.

FIDEL: I love these green ones.

> *HASSAN does not reply.*

> They're definitely my favourite. Bit like fudge – only much tastier.

> *FIDEL offers HASSAN a sweet.*

> Want one?

HASSAN: No – thank you.

FIDEL: It's alright. Lux ain't gonna want one. Bought too many – got greedy. Go on.

> *FIDEL offers HASSAN again.*

HASSAN: You know Lux?

FIDEL: Yeah.

HASSAN: I am a friend of Tasleema's. In fact, I am waiting for her.

FIDEL: What a coincidence. I'm waiting for Lux.

> *HASSAN relaxes. He approaches FIDEL and sits close. He takes a sweet.*

HASSAN: Pistachios. Hmmm… Fresh.

FIDEL: Said he made 'em this morning. By the way – I'm Fidel.

HASSAN: Ah – you are famous.

FIDEL: Am I?

HASSAN: In my country, we say Fidel Castro looks like an Afghani.

FIDEL laughs.

My name is Hassan.

HASSAN and FIDEL slap palms.

FIDEL: I seen you around.

HASSAN: I've seen you too.

FIDEL: Lux talks about you.

HASSAN: Good things or bad?

FIDEL: It's all bad.

They laugh.

Where d'you reckon those girls have got to?

HASSAN shrugs.

I heard Tas is in a bit of a spot.

HASSAN: Her father…

FIDEL: Yeah – he's blown a gasket.

HASSAN looks puzzled.

Angry.

HASSAN: And it is my fault. She was out with me.

FIDEL: You evil tempter.

HASSAN: I am not evil.

FIDEL: It was a joke.

HASSAN: Ah.

FIDEL: It ain't your fault man. Those girls have got minds of their own.

HASSAN: Tas took too many risks. And now she is being punished.

FIDEL: Don't worry. I'm sure it'll blow over.

HASSAN: I'm not so certain.

FIDEL: You really reckon he's gonna bundle her onto a plane?

HASSAN: There is a real possibility.

Beat.

FIDEL: Lux says you're from Afghanistan.

HASSAN: Yes.

FIDEL: How long you been here?

HASSAN: Just over two years.

FIDEL looks curious.

FIDEL: You got refugee status here?

HASSAN: Not yet.

FIDEL: But surely it's safe to go back there now?

HASSAN: I don't believe it is safe. Some of the Taliban fled, some were killed but many are still there, watching waiting in the shadows for their time to come again. It is much easier to shave a beard than to grow one. They will kill our President Karzai and then we will be back in hell again.

FIDEL: But don't they need young blokes like you to kind of – well, help rebuild the country?

HASSAN: My mother was executed for teaching girls.

FIDEL: I'm sorry.

HASSAN: There is not much of a country to go back to. No water, no electricity just bombed out houses everywhere. My cousin. He writes to us regularly. He keeps us informed. Everyone is afraid the international peace-keepers will leave and then the fighting will start again. I don't want to go back. There is nothing for me there.

FIDEL: So both you and Tas are under threat.

HASSAN: Yes.

FIDEL: Easiest thing to do would be to get married. Then you could both stay.

HASSAN is silent.

Isn't she almost eighteen?

HASSAN: Yes, in a week's time. Why?

FIDEL: Just need to get her to swipe her passport. Hide it. He can't get her on a plane without her passport. Then you two can get married when she's eighteen and you're both safe.

HASSAN: You make it sound so easy.

FIDEL: It is. My parents' mates – they're always marrying refugees to help 'em to stay. Then when they get permanent status, they divorce and marry someone else. It's their way of organising a quiet revolution.

HASSAN looks thoughtful.

OMAR shuffles in, looking depressed. He is followed closely by QUASIM who looks nervy, jumpy.

HASSAN: Mr Happy again.

OMAR is silent.

What happened?

OMAR looks suspiciously at FIDEL.

OMAR: What's he doing here?

HASSAN: He's a friend.

OMAR: You been hanging out with the wrong sort Hass. (*To FIDEL.*) I hope you're not sniffing around here for Lux.

FIDEL: What's it to you?

OMAR: I don't remember inviting you to sit on my front door step.

QUASIM: Leave it Omar…

FIDEL: This particular step belongs to you does it?

OMAR: This is my patch so fuck off.

FIDEL: Don't be ridiculous. It's a free country.

OMAR: Maybe for you white boys but it ain't for us. Now hop it.

FIDEL stands up and squares up. HASSAN stands uneasily too.

HASSAN: Fidel ignore him. Omar, don't…

QUASIM: Yeah, ease up man.

FIDEL: (*To OMAR.*) What is your problem? I ain't the enemy.

OMAR moves towards FIDEL and viciously tries to remove him. FIDEL is taken by surprise by OMAR'S strength and is winded. He falls to the floor and tries to catch his breath.

OMAR: I know who you are. Got the hots for Lux eh – I
got news for you – she's just messing around with you –
she's not interested in your pasty face. She told me she's
gonna dump you.

FIDEL: She never.

*OMAR moves forward again to kick FIDEL in the stomach,
but HASSAN grabs OMAR's leg and QUASIM holds OMAR
back. There is a struggle but HASSAN soon gets the better of
OMAR and pins him down.*

HASSAN: Omar! Stop it now.

FIDEL turns to go.

FIDEL: I don't want no trouble. (*To HASSAN.*) You think on
what I said.

HASSAN: Thank you.

FIDEL exits. HASSAN helps OMAR up.

Stupid boy!

OMAR: Why d'you stop me? He's got no right to…

HASSAN: You can't just lash out like some wild animal.

OMAR: He gives me the creeps.

HASSAN: What is the matter with you anyway?

Beat.

QUASIM: He's been suspended from school.

HASSAN: What did you do?

OMAR: Nothing.

HASSAN: You must have done something.

OMAR: I didn't do nothing. I'm innocent. It's such a shit
school. They think we're all guilty. One white kid gets

stabbed in a fight and they haul us all in. Black kids can get lynched as far as they're concerned but it's much more serious when one of them gets injured.

HASSAN: So, what's the story?

OMAR: Someone snitched on me.

QUASIM looks worried.

HASSAN: Omar, what have you done?

OMAR: I ain't done nothing but I've got a knife. I use it for protection. It's a vicious school – teachers are too scared to deal with it – so we got to look out for ourselves.

HASSAN: You take a knife into school?

OMAR: Don't look so shocked. I know about you Afghanis – you knife blokes if they even look at your wives.

HASSAN: That's not quite true.

OMAR: You're warriors.

HASSAN: Not all of us.

OMAR: It's in your blood.

HASSAN: Let's just stick to your story shall we?

OMAR looks away.

QUASIM: This Albanian geezer, Agron, he was getting bullied by these white kids. So, Omar loaned him his knife.

HASSAN looks incredulous.

OMAR: I know. It wasn't a very smart thing to do.

HASSAN: And now the school knows it was your knife and they suspend you?

OMAR: Yeah. But Agron wouldn't have told them.

HASSAN: He must have in order to…

OMAR: No. Them boys have got honour – they'd never grass to the enemy – been through too much themselves. It was someone else.

HASSAN: You must tell the teachers about what the white boys were doing.

OMAR: As if they'd listen. Think we're all animals and any sign of strife, they haul the pigs in. Bloody hate 'em I do. Always picking on us. Any trouble and they blame us. Especially when it's their lot that always start the trouble in the first place. As far as they're concerned, we should all bugger off back to Pakistan, or Bangladesh or wherever the hell we came from.

QUASIM: This country doesn't like foreigners.

OMAR: That's why we got to protect our people man. We've had enough of this crap. No more lying down while they kick us around. We're not like our parents. They never stuck up for themselves. Work, that's all they know. Working in crap jobs. Never getting promoted.

OMAR gets up and paces.

What chances do I really have in this place? The school's like a prison. It's tenth from the bottom in the national league tables. Three years we've had four new head teachers. Each one leaves with a nervous breakdown. The classes are way too big and it's like a zoo. Half the kids don't speak English and the other half are so fucked up, they've virtually all got social workers. What chance do I have? What the fuck do they expect? No one looks out for me, so I gotta look out for myself.

HASSAN: You have a chance because you have food in your bellies, books in your classroom, peace in the country. You don't know how lucky you are.

OMAR: Okay, so your country's fucked up – badly – by the Americans, the Taliban and all that. Exploited and dumped on… But this country – our parents all flocked to it 'cos it was supposed to be the centre of Western civilisation.

HASSAN: Maybe we expected too much of it. Maybe we should stop being so angry and try and change it.

OMAR: Can't change things without being angry. Martin Luther King was angry. So was Mohammed Ali and Malcom X…

HASSAN: Two of them are dead and the other one spent his whole life having his head punched for a living.

OMAR: But they changed the world.

HASSAN: Great men. But how are you changing the world?

OMAR: I'm sticking up for my brothers.

HASSAN: Playing war games? You're like a kid you are. You're not helping anyone especially not yourself. You put your head down and work hard at school and you could…

OMAR: What? End up working in a factory for peanuts? Laughed at by those bastard teachers – They've all written us off. Whose gonna give a Paki boy with no qualifications a job in this city? It's bad enough when you do have letters after your name. We gotta be better than them. We always gotta prove ourselves.

HASSAN: Taking a knife into school isn't the way.

Beat.

OMAR: I know. I messed up. I get suspended or excluded and I'm straight back to Bangladesh – looking after water buffaloes.

HASSAN: Sometimes Omar, I think you do these things deliberately.

OMAR: What d'you mean?

HASSAN: I think you want to be sent home.

Beat.

OMAR doesn't reply.

The three of them sit on the step looking maudlin.

Our appeal failed.

OMAR: What?

HASSAN: I heard this morning.

OMAR: Shit.

HASSAN looks distraught.

QUASIM: What's that mean?

HASSAN: They are deporting us. I thought I had made my home here.

OMAR: When are they gonna do it?

HASSAN: Today, tomorrow – I don't know.

OMAR puts his arm around HASSAN to try and comfort him.

Scene 2

HASSAN's dream.

HASSAN is in prison. He is crouched on the floor looking tired and afraid. He has obviously been beaten. His hands are tied. He stands and addresses the audience as if they are officials.

HASSAN: I have papers. If you will let me get them from home. I am still at college… I am studying to be a

doctor. My father is a teacher at the University and my mother…where is she? Where have you taken my mother?

HASSAN looks wildly around the audience.

His mother steps forward. She is on a raised platform, almost hovering so that HASSAN has to look up at her. She is dressed in a blue burka. Head and face covered.

Ammi? Is that you?

The figure is silent but simply stands.

Ammi? What are you doing here? Are you alright? Are they treating you well?

The figure is silent. HASSAN looks at the figure with growing horror.

Who are you? Where's my mother?

What have you done to her?

The figure crouches down and looks at HASSAN. She reaches out her hand, HASSAN tries to get near her but his hands are bound and so he can't reach her.

I told you – it wasn't worth it. I told you to stop teaching. Someone must have informed on you. I came back and you were gone. Nothing but pages…pages of your books, ripped out…mess everywhere. They took you away…no one could tell me where…

The figure stands up again.

HASSAN calls for his mother and sobs.

Ammi? Ammi…don't leave me here. Don't go. They're calling me names …they beat me with sticks. They're hurting me… Can't you stop them? Please… I'm scared. I'm really scared.

The figure hesitates and then turns to leave.

You said we'd be safe – that no one would know.
Someone must have told them. Where are you going?
Don't…don't…

The figure leaves. HASSAN continues to call out desperately.

Ammi! Ammi!

Scene 3

Bus stop.

We are at a bus stop. FIDEL is standing waiting for LUX. She arrives out of breath.

FIDEL: You okay?

LUX is bent over double as she tries to catch her breath.

LUX: Wait…

FIDEL rubs her back affectionately.

Thought I'd missed you.

FIDEL: I've only been waiting here half an hour.

LUX: Sorry. Fidel – what were your parents doing in our shop?

FIDEL: Tell me about it.

LUX: I saw them come in this morning. Buying bloody packets of rizlas they were.

FIDEL: They're so embarrassing.

LUX: It was deliberate wasn't it? They were trying to suss my fossils out weren't they?

FIDEL: They've been dying to meet your parents. I tried to put them off. They didn't say anything did they? You know about…us?

LUX: No. Your dad kept winking at me though.

Both FIDEL and LUX look anxious and then see the funny side of it. They start to laugh.

What are your parents like?

FIDEL: Don't…

LUX and FIDEL look surreptitiously around to check the coast is clear and then have a quick snog.

You never let me meet your mates.

LUX: It's kinda awkward.

FIDEL: Feel like I'm a hidden boyfriend.

LUX: They'd just take the piss.

FIDEL: You're ashamed of me.

LUX: No.

FIDEL: Your parents don't know about me, your mates give me the evil eye.

LUX: Who?

FIDEL: That Omar geezer.

LUX: He ain't my mate…

FIDEL: Made me feel like I was public enemy number one. Actually, I think he fancies you.

LUX: He's just being…protective…but he's a git.

FIDEL: I'm not out to hurt you.

LUX looks at FIDEL and touches his face gently.

LUX: I know.

FIDEL: You and me Lux. It feels good but I can't work out where I stand with you.

LUX: It's confusing.

FIDEL: What is?

LUX: We're from like…completely opposite worlds.

FIDEL: What difference does that make?

LUX: I dunno.

FIDEL: It doesn't have to be anything heavy – we could just have a laugh but you need to make up your mind…about me that is.

We cut to:

Outside Ladoo.

TASLEEMA and HASSAN are standing outside Ladoo. TASLEEMA looks anxious.

HASSAN: I have a plan.

TASLEEMA: I've gotta get back. Can't hang around. Abba's waiting for me…

HASSAN smiles.

HASSAN: You must hide your passport. Then he can't take you out of the country. You know where it is kept?

TASLEEMA: Yeah.

HASSAN: Then, in one week you will be eighteen.

TASLEEMA: That won't make no difference to Abba. According to him, until I'm married, I'm his property.

HASSAN: Exactly.

TASLEEMA: Eh?

HASSAN: I will marry you.

TASLEEMA: What?

HASSAN: It solves your problem.

TASLEEMA: Hold on…

HASSAN: You can be free of your father.

TASLEEMA looks astonished.

We cut back to:

Bus stop.

LUX: You told him what?

FIDEL: Seemed the easiest solution.

LUX: Who asked you to stick your nose into it all?

FIDEL: He's been through a lot that Hassan. I was just trying to help him out.

LUX: For fuck's sake.

FIDEL: What's the matter with you?

We cut back to:

Outside Ladoo.

TASLEEMA: But we've only really known each other six months…

HASSAN: But don't you feel it? We were meant to be together.

TASLEEMA: What about school, college…?

HASSAN: I will support you.

HASSAN laughs and hugs TASLEEMA. She is taken aback by his reaction.

It's what I miss the most. Having people who love me in the house. A heartbeat again.

TASLEEMA: You really mean it? You'd stand by me?

HASSAN: We should get married as soon as possible.

HASSAN grabs TASLEEMA and kisses her.

We cut back to:

Bus stop.

LUX: You did the wrong thing Fidel. It ain't right.

FIDEL: It's only a piece of paper.

LUX: That ain't how she's been brought up though is it?
 She'll have to turn her back on her whole family.

FIDEL: She'll be free.

LUX: It's not that simple.

FIDEL: Why?

LUX: Sometimes Fidel, you gotta leave people to sort out
 their own problems. Not march in like some do-gooder
 fucking white social worker.

FIDEL: I only mentioned it. It's no big deal. She can always
 say 'no'.

LUX: I bet he's turning on the screws right now. Putting on
 the pressure.

FIDEL: He's a nice bloke. She could do a lot worse.
 Anyway, I don't see that either of 'em have got many
 options.

LUX turns away, disgusted.

LUX: That's not for you to decide. I've gotta go.

FIDEL: You're always running away.

LUX: I'll catch you later…

FIDEL: Wait.

LUX: I can't hang about…

FIDEL: Lux…

LUX: Gotta see if Tas is alright.

LUX dashes off. FIDEL watches her go – irritated.

We cut back to:

Outside Ladoo.

HASSAN: Haven't you always wanted to escape from your family? Now is your chance. Be who you want to be, stand on your own two feet and live your own life?

TASLEEMA: It won't be easy.

HASSAN: We will manage.

TASLEEMA: Is this gonna be like a proper marriage? I mean, like living as husband and wife?

HASSAN: I love you Tasleema and I want to make you happy. I don't want to see you going through so much worry just to finish school. I hate to see you hurt and living in fear. If you do not care for me, then maybe our marriage wouldn't work.

TASLEEMA: No. I love you too…but…marriage?

HASSAN: It is a natural progression. People do it all the time. So, we are marrying earlier than most and maybe your Abba is forcing our hand but would it be so bad?

TASLEEMA laughs.

TASLEEMA: No.

HASSAN: Every morning, we will wake up and see each other.

TASLEEMA looks embarrassed.

No more hiding, or lying. We can just live.

TASLEEMA: You really love me? You're not just doing this because of the situation?

HASSAN goes down on his knees. He puts TASLEEMA's hand on his heart.

HASSAN: On my life, I give you my word. I want to be your husband, to love you until we both grow old, to always be there for you.

TASLEEMA laughs – delighted. Suddenly there is an almighty racket. We hear shouting.

OMAR: Fucking traitor! Grass. I'll have your balls for breakfast.

QUASIM climbs out of the upstairs window, terrified. TASLEEMA and HASSAN both look up.

QUASIM: He's trying to kill me.

QUASIM climbs down fast from the flat above 'Ladoo'. OMAR sticks his head out of the window, furious.

OMAR: You snake in the grass, double crossing, low-life scum of the earth. It was you. You told 'em it was my knife.

QUASIM: It wasn't my fault. They questioned me. It slipped out.

OMAR: I've been suspended because of you. My uncle's gonna kill me because of you. Call yourself a mate? You're a turncoat. Not fit to lick my boots.

QUASIM gets down onto the ground. He finds his nerve standing behind HASSAN. He shouts back up at OMAR.

QUASIM: You're just a tosser.

OMAR: I'll get you for this.

QUASIM: No you won't. You touch me and I'll tell 'em about those drugs you sell and those stereos you fenced and…

OMAR: Shut up!

QUASIM: Think you're so clever. You're a sad washed out failure.

OMAR: Come here and say that.

QUASIM: No wonder your parents dumped you.

OMAR looks hurt.

You would have let Agron take the blame for everything.

OMAR: He was the one who did the stabbing, not me.

QUASIM: He wouldn't have thought about if you hadn't given him the knife.

OMAR: Oh, so it's my fault is it?

QUASIM: You got no honour. You're a lying, cheating shit. Blame everyone else except yourself. Get everyone else in trouble and then walk away.

OMAR: You little sneak. Don't you ever come back here again.

QUASIM: Think I wanna hang out with a loser?

QUASIM storms off.

OMAR looks defeated.

Scene 4

OMAR's dream.

OMAR is sat in the middle of the space in a straight jacket. He is in an airport lounge.

TANNOY: Will passengers boarding flight SB300 to the Siberian desert please board from gate number 666.

OMAR looks afraid. He struggles to free himself from his straight jacket.

OMAR: Uncle? Uncle? Please, look, I'm sorry. It was an accident.

He turns to look at the sweet shop.

Look – I promise I'll help out more in the shop. I'll sweep up outside regular – like you asked me.

TANNOY: Will Mr Omar Khan for flight SB 300 please proceed to gate number 666.

HASSAN, QUASIM and FIDEL enter. They look stern. QUASIM is carrying a suitcase.

OMAR: Man. Thank God you're here. You gotta help me out.

HASSAN: You've had your chance.

QUASIM: We've come to take you to the plane.

FIDEL: Up you get.

OMAR: You're not going to let them take me? It's hard labour out there.

HASSAN: You should have thought about that before.

FIDEL: We've had enough of your sort.

OMAR: Please. Once I'm on that plane – Uncle won't let me back – innit.

TASLEEMA and LUX enter. They are dressed as cheer leaders.

What the fuck?

TAS / LUX: Give me an L.

Give me an O.
Give me an S.
Give me an E.
Give me an R.

They shake their pom-poms.

L-O-S-E-R.

OMAR: Mates! Give me a break. Help me out of this thing…mates?

OMAR looks around at his friends but is met with stony stares. QUASIM, FIDEL and HASSAN stand silently to attention, hands clasped resolutely in front of them, Men In Black-style. Each don a pair of black shades.

TASLEEMA and LUX continue their chant.

TAS / LUX: Loser! Loser ! Loser!

OMAR: Whose fucking side are you on?

HASSAN: Not yours.

FIDEL: Definitely not yours.

QUASIM: Yeah… I mean…no.

OMAR gets up and makes a run for it. He makes it into the audience but HASSAN manages to rugby tackle him to the ground and hauls him out. OMAR screams all the way.

OMAR: Uncle! Uncle! No! No!

As OMAR is dragged out by HASSAN, FIDEL clicks his fingers at the girls. They stop their chanting immediately and exit. QUASIM picks up the suitcase and exits, followed closely by FIDEL.

Scene 5

Outside Ladoo.

LUX sits and waits for TASLEEMA. She looks bored. It is night time. 'Ladoo' is lit up but has the closed sign up. TASLEEMA enters.

LUX: What sort of time d'you call this?

TASLEEMA: I'm really sorry but I couldn't get out. Abba's watching me like a hawk. Think he must sense something.

LUX: How did you get out?

TASLEEMA: He's standing on the street corner look –

LUX peers across the street.

I can't stay long.

LUX: So – what's happening? You sounded a bit fucking mysterious on the phone.

TASLEEMA: I'm just thinking things through.

LUX: You gotta have a plan of action.

TASLEEMA: I couldn't find my passport. Abba got there before me.

LUX: Shit.

TASLEEMA: He's bought the ticket for Bangladesh. I'm leaving next week – just after my birthday. He's got it all worked out. If he does it before my eighteenth, I'm still a child and it's illegal.

LUX: It's illegal either way.

TASLEEMA: The only way forward is to…

LUX: You can't marry Hassan.

TASLEEMA: How did you…[know]?

LUX: Fidel told me.

TASLEEMA: Who told him?

LUX: For fuck's sake Tas. There must be another way.

TASLEEMA: You should be happy for me. I can get away from my dad. He won't be able to threaten me no more. I can carry on at school. I can get me some qualifications…

LUX: This isn't the way. You're walking into a trap. First your father controlled you, now Hassan will.

TASLEEMA: Hassan will look after me.

LUX: Like hell he will.

TASLEEMA: He wants to marry me. He really loves me.

LUX: I don't believe this.

TASLEEMA: It's not exactly what I had planned but we could be alright.

LUX: Will you please listen to yourself? Think you're gonna play happy families with him?

TASLEEMA: He's a good bloke.

LUX: You don't know nothing about him. What if he turns out to be a bastard? Wouldn't be the first time that'd happened.

TASLEEMA: I'll take a chance.

LUX: Next thing you know, he'll be trying to pressurise you to have babies.

TASLEEMA: No…

LUX: He's only after one thing Tas. He's not interested in you. He wants a passport.

TASLEEMA: That's not true… I know what I'm doing. I've made up my mind. I'm going to get married and live with Hassan and his dad.

LUX: You've never even met his dad!

TASLEEMA looks away.

You wanted to be someone – remember? On your own terms. You can wait to get hitched 'til you know you're doing it for the right reasons. You marry Hassan, I know you'll hate yourself for the rest of your life. You'll be trapped in a life you never wanted, in shit jobs, in shit housing…

TASLEEMA: How do you know all this?

LUX: I look at my mum every day, sitting behind that till in that dingy corner shop. Believe me, I know.

TASLEEMA looks over at her father across the road anxiously.

And look what happened to your mum.

TASLEEMA: I'd better go.

LUX: Please, don't do this. Think things through – properly.

TASLEEMA: I have.

LUX: You haven't. You're just reacting.

TASLEEMA: I've only got a week.

LUX: Fidel says you could stay in one of them refuges – his parents know some Asian solicitor who specialises in helping…

TASLEEMA: I don't wanna hear what he has to say.

LUX: He knows what he's talking about.

TASLEEMA: Tell him to mind his own fucking business. I don't need some white rich kid telling me what to do

with my life. Just 'cos he's knocking you up, suddenly he's become a world expert.

LUX: You're just being nasty now.

TASLEEMA: I don't want to live in some grotty refuge with a bunch of losers. I ain't a victim. I don't need Fidel's advice and I don't want his pity – right?

LUX is quiet.

You can run back and tell your white boyfriend – I know what I'm doing.

OMAR enters.

OMAR: Hey – Tas – nuff respect.

TASLEEMA looks over anxiously at her father.

That your Abba? Keeping a close eye – eh?

OMAR smiles and waves at ABBA.

Bit late. He know you're getting hitched?

TASLEEMA: Who told you?

OMAR: Hassan. Very excited he is. It's a noble thing you're doing Tas.

LUX: What you going on about?

OMAR: It's an act of solidarity with our Muslim Brethren from Afghanistan. Dunno why any of us want to live in this bastard country. They don't want us here. Still, I wouldn't want to go back to Afghanistan now. Flattened it didn't they? It's just a pile of rubble full of starving people.

TASLEEMA: He asked me to marry him.

OMAR: I s'ppose it's one way of helping him to stay. You know he's asked about four girls to marry him over the

last couple of years but you came out trumps Tas. I gotta hand it to you – you're…

TASLEEMA: (*Upset.*) Four other girls?

OMAR: Yeah. He's desperate to stay here.

TASLEEMA looks at OMAR absolutely stunned.

TASLEEMA: I gotta go.

LUX: Tas!

TASLEEMA exits in hurry. LUX watches her go anxiously. OMAR looks at LUX.

OMAR: She thought he'd asked her like – for real?

LUX is silent.

Honestly, you girls, you're soft in the head. A little sweet talk and you fall for it hook line and fucking sinker. Hassan's the smoothest operator I know – surely she could see that? Hassan and his dad got their marching orders three days ago.

LUX: Marching orders?

OMAR: Their final appeal failed; they're being deported back to Afghanistan. He told me himself.

LUX sits on the steps.

LUX: How's it going with you? What's your uncle say?

OMAR: He was unbelievably fucking decent. I mean understanding, concerned, upset at what I did but at the end of the day – supportive. Made me feel this small.

LUX: He's not sending you packing?

OMAR: No. I got wait to see what the school decide, then if they chuck me out, I have to look for a college to take me, he wants me to retake my GCSEs and I have to help him in the shop.

LUX: Not a bad result.

OMAR: Working in the shop's a bit of a downer.

LUX: Could've been a lot worse.

OMAR: Going back wouldn't have been such a bad thing. But I guess I owe it to the family to at least try and get some grades, get a decent job, send money back home – that sort of thing. Parents don't really want me back. In fact they'd be really fucked off if I turned up in their village. I'm an investment innit? (*Sad.*) Gotta give 'em a return with interest.

LUX leans her head on OMAR's shoulder.

You making a pass at me?

LUX: No.

OMAR: 'Cos I could only ever see you as my little sister…

LUX: I'm older than you.

OMAR: Are you?

LUX: By at least a year.

OMAR: Oh. Too old for me then. I never go for older women. Mind you, if you were Salma Hayek or Naomi Campbell, I might make an exception.

LUX: Shut up Omar.

OMAR smiles, kisses LUX on the head and puts his arm around her. They sit together.

Scene 6

Outside Ladoo.

It is a few days later – early morning. HASSAN is waiting, pacing, up and down. He is dressed smartly. TAS enters.

HASSAN: Are you ready?

TASLEEMA looks away.

I've been rehearsing my speech to your father all night. Look…

He produces a crumpled up piece of paper.

I have it all written – in Pashtun – because I can only speak from my heart in my own language. How was your father's mood this morning?

TASLEEMA: Hassan…

HASSAN: As soon as he gives his blessing, we must make arrangements. We should have a big party – yes? Invite all our friends…

TASLEEMA: You can't ask my father.

HASSAN: It doesn't matter if he says 'no' but we must do these things properly. We will go ahead anyway. My father is eagerly waiting to meet you.

HASSAN tries to kiss TASLEEMA but she turns away.

Are you okay?

TASLEEMA: No. Hassan. It's ridiculous. I can't marry.

HASSAN: But we've been through all this. We agreed, it's for the best…for you…

TASLEEMA: No. I'm too young. I need to finish my school.

HASSAN: You are nervous – yes? I understand, it's a big step. But I want you to be comfortable. Not to be humiliated by the community.

TASLEEMA: No.

HASSAN: Are you afraid of your father? I can work on him. He will listen to me. Sometimes, man to man is good.

TASLEEMA: This isn't about Abba. It's my decision. I can't marry you. Thank you for offering to help me though. It was very sweet.

TASLEEMA turns to go.

HASSAN: Tasleema! Explain to me. What is happening?

TASLEEMA: I told you.

HASSAN: No. You can't change your mind just like that.

TASLEEMA: Yes I can. You don't love me Hassan. You're only after one thing.

HASSAN: What are you saying?

TASLEEMA: I know you're being deported. I know you're desperate to stay in the country – but I can't just be your passport.

HASSAN: Who told you this?

TASLEEMA is silent.

It is true, I am being thrown out of the country but that's not the only reason. I want to be with you.

TASLEEMA: And what about the four other girls you tried to marry?

HASSAN: What four other girls?

TASLEEMA: Don't lie to me Hassan. I know!

HASSAN: We must marry. For both our sakes.

TASLEEMA is silent.

I have a chance here, in this country, to be someone, to make something of my life. I want to work, I don't want

beg from this country. I want to contribute in some small way. You are like a small miracle to me. You can help me rebuild my life.

TASLEEMA: And what about my life?

HASSAN: We would be happy together…please…

TASLEEMA is torn.

HASSAN: I would help in any way I can to get you through school. I want to help you. I don't want to go back. I have made a life for myself here, made friends, made plans – so many dreams!

TASLEEMA: And I have dreams too. I want to get some qualifications, have choices, decide for myself…

HASSAN: Let me speak to your father.

TASLEEMA: Hassan…listen to me.

HASSAN: Look me in the eye and tell me you would throw me back to the wolves. I have travelled long distances – you can be my shelter. I saw so many people killed. My mother was killed. She was dragged from our house because she was teaching girls secretly in our house.

TASLEEMA: I'm sorry…

HASSAN: They executed her, shot her in the street and I wasn't even there! They imprisoned me, beat me and my father and then threw us back out onto the streets. We escaped over the border. I had to hide under sacks of salt over to Pakistan. I can't go back there.

TASLEEMA: It's not fair. You can't expect me to give up everything.

HASSAN: What would you be giving up? It is an exchange. I am offering you a new life!

TASLEEMA: It's not the life I want though. I don't want to be tied down at this age. My life's only really begun.

HASSAN: And if you refuse me, my life will end.

TASLEEMA: No. It won't Hassan.

HASSAN: My mother was killed. I can't go back. I still have nightmares. She comes back to me when I am sleeping and she reaches for me but I cannot get to her.

TASLEEMA: What do you expect from me?

HASSAN: Our marriage will heal my wounds.

Beat.

TASLEEMA: I can't do it.

HASSAN is stunned.

I can't go through with it. Maybe a few years down the road, another place, perhaps we could have had a chance. But I have to do this for myself.

HASSAN: Where will you go?

TASLEEMA: I'm leaving home. Gonna try and make it on my own.

HASSAN: Where though?

TASLEEMA: I don't know yet.

HASSAN: What about me?

TASLEEMA: I'm sorry. We would have been doing it for all the wrong reasons.

HASSAN: My life is not reason enough?

TASLEEMA: I don't trust you. I look at you and I'm filled with love and longing and hope and then I hear you've been trying to get married ever since you got here.

HASSAN: I am desperate to stay here. How can you blame me?

TASLEEMA: I don't. But you lied to me.

HASSAN: And if I had told you my real situation?

TASLEEMA: If you'd been straight right from the start …maybe…but this way, I'll never know.

HASSAN: You won't survive five minutes on your own. You'll end up wandering the streets like all those shattered people out there. There is evil in this city. How will you cope?

TASLEEMA: I'll manage. I'm sorry I couldn't help you. I wish you all the luck in the world.

TASLEEMA tries to exit. HASSAN grabs her and pulls her back. He holds on tightly to her hand, twisting it slightly.

HASSAN: No. No, you cannot leave me like this…all my plans…

TASLEEMA: Let go.

HASSAN: Do you know what you have done to me?

TASLEEMA: (*Urgent.*) You're hurting me.

HASSAN: I love you.

TASLEEMA: I don't believe you.

HASSAN: Tell me, how can I prove it?

TASLEEMA: It's too late.

HASSAN: Please…

TASLEEMA: You're hurting me…

HASSAN: You said you loved me. We exchanged a vow.

TASLEEMA: Let go.

HASSAN: Please. Just do this for me. I beg you. Marry me and then we need never see each other again. Is that what you want? It's just a formality. If we do it now, quick, I could still be saved.

TASLEEMA: Hassan, my hand…

HASSAN lets go. TASLEEMA backs away.

I'm sorry.

HASSAN: You never even gave me a chance. I could have been a husband – a good husband. I would have loved you…

HASSAN looks distraught. TASLEEMA looks at him with pain and then exits.

HASSAN calls out and cries.

Tasleema!

Scene 7

Outside Ladoo.

We are back outside 'Ladoo'. It is morning – a few weeks later. LUX enters. She stands waiting, looking anxious. FIDEL enters. They hug.

FIDEL: He's gone.

LUX: How was he?

FIDEL: Resigned. Kept asking after Tas – poor sod. It ain't gonna be easy for him.

LUX: At least he's got his dad with him.

FIDEL: Yeah…

QUASIM enters struggling with a heavy suitcase. He is followed closely by TASLEEMA. LUX rushes forward.

LUX: You got out?

TASLEEMA: I just told Abba I was leaving and he…did nothing.

LUX: He just let you walk?

TASLEEMA: Yeah. Face all crumpled up but didn't stop me. Didn't even look up when I left.

TASLEEMA looks upset.

I felt sorry for him.

QUASIM: I'll marry you if you want Tas.

LUX looks at QUASIM incredulous.

LUX: Oh great.

QUASIM: Straight up. When I get to sixteen…

TASLEEMA: Thanks for the offer Kas but no…

QUASIM: Worth a try.

LUX: Happy birthday.

LUX hands over a present and a card to TASLEEMA.

TASLEEMA: Thanks, I'll open it on the coach. (*To FIDEL.*) You seen Hassan?

FIDEL: Yeah. He's gone. Germany.

TASLEEMA: Germany?

FIDEL: It was his first port of entry so…I guess he'll carry on apealing from there.

TASLEEMA looks upset.

LUX: You did the right thing Tas.

TASLEEMA: I hope he's alright.

OMAR appears from the window above the shop.

89

OMAR: All set Tas?

TASLEEMA looks up.

I'm escorting you to the station.

TASLEEMA: Honestly, I don't need…

OMAR: No worries. Better than double maths with Crater Face.

TASLEEMA: They let you back in?

OMAR: Yep. Said they'd give me another chance but the reality is – I'm giving them another chance. Them and this lousy country.

OMAR disappears again.

LUX: Your sister meeting you at the other end?

TASLEEMA: Yeah. She sounded quite excited. Said she's got a spare room made up for me. She's got a job now.

LUX: Doing what?

TASLEEMA: Secretarial stuff. Apparently there's a college near her, said I could enrol there.

LUX: What about your mum?

TASLEEMA: I'll keep in touch. Come down and see her when I can.

OMAR emerges from the shop.

FIDEL: Alright Omar.

OMAR: Wotcha.

FIDEL: How're yer doin'?

OMAR: Alright.

OMAR continues to eye FIDEL warily.

LUX: You know Fidel don't you?

OMAR: Yeah. We've met. Guess there's no hope for you now Lux.

LUX: Don't start…

OMAR: That's the problem with you Hindus. Thought I could save you, lead you into the arms of Allah.

FIDEL: Arms of Allah or arms of Omar?

OMAR: (*Laughs.*) Nice one. (*To LUX.*) Least he's got a sense of humour.

OMAR produces a box of Indian sweets with 'Ladoo' emblazoned on it. He hands it to TASLEEMA.

Do something with that will ya?

TASLEEMA: What is it?

OMAR: A box of Ladoo – birthday thing – you know.

QUASIM skulks around at the edges. OMAR finally clocks him.

Look who it isn't. Old snake in the grass himself. (*He hisses.*) Hissss… What d'you want?

QUASIM: Just come to wish Tas luck.

OMAR: Little bastard.

QUASIM: I was gonna go to the station with her.

OMAR: You?

QUASIM: Carry her case.

OMAR: Oh. Alright then.

QUASIM: You won't have a go at me?

OMAR: Would I?

QUASIM: Promise?

OMAR: Promise.

QUASIM sidles up to OMAR who smiles benignly and then the moment he's close, he grabs the boy and puts him in a head lock.

QUASIM: Aaaargh! Aargh!

OMAR: Little sneak.

QUASIM: You promised you wouldn't…

OMAR: But I'm a lying cheat – remember?

TASLEEMA: Put him down Omar.

LUX: For God's sake. Grow up.

QUASIM: Faggot! Let go.

OMAR: I don't think you're in a position to hurl insults at me sonny Jim.

FIDEL, TASLEEMA and LUX pull OMAR off QUASIM who straightens himself up.

QUASIM: You still want me to come with you?

OMAR: Go on then.

LUX hugs TASLEEMA.

LUX: Hope it goes well Tas.

TASLEEMA: Thanks. Phone me.

LUX: I will.

TASLEEMA hesitates before hugging FIDEL too.

TASLEEMA: Look after her for me. She can be a bit of a handful.

FIDEL: Tell me about it.

TASLEEMA takes one last look around her and exits, followed closely by OMAR and QUASIM, still struggling with the suitcase.

OMAR: (*To QUASIM.*) Wimp.

QUASIM: You try carrying this.

OMAR: You need to build up your muscles.

QUASIM: (*Calls out.*) What you got in this Tas? Bricks?

FIDEL puts his arm around LUX who watches after TASLEEMA sadly.

FIDEL and LUX kiss.

The End.